SISTER WENDY'S
1000
MASTERPIECES

SISTER WENDY'S 1000 MASTERPIECES

SISTER WENDY BECKETT

CONTRIBUTING CONSULTANT PATRICIA WRIGHT

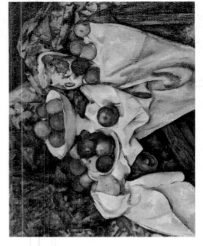

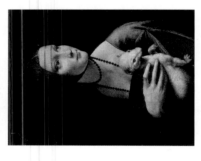

DK PUBLISHING, INC.
New York
www.dk.com

A DK PUBLISHING BOOK
www.dk.com

Senior editor Louise Candlish
Senior art editor Heather McCarry
US editor Barbara Minton
Senior managing editor Anna Kruger
Deputy art director Tina Vaughan
Production controller David Proffit, Louise Daly
Picture researchers Jo Walton, Sam Ruston, Louise Thomas
DTP designer Robert Campbell

PRODUCED FOR DORLING KINDERSLEY BY STUDIO CACTUS

I would like to dedicate this book to Tricia Wright, without whose support, research, insights, and inspiration, it would never have been begun; let alone finished. Thank you dear Tricia, invaluable friend.

First American Edition, 1999
4 6 8 10 9 7 5

Published in the United States by DK Publishing, Inc.
95 Madison Avenue, New York, New York 10016

A Penguin Company

Copyright © 1999 Dorling Kindersley Limited, London
Text copyright © 1999 Sister Wendy Beckett

DK Publishing books are available at special discounts for bulk purchases for sales promotions or premiums. Special editions, including personalized covers, excerpts of existing guides, and corporate imprints can be created in large quantities for specific needs. For more information, contact Special Markets Dept./DK Publishing, Inc./95 Madison Ave./New York, NY 10016/Fax: 800-600-9098.

Library of Congress Cataloging-in-Publication Data

Beckett, Wendy.
Sister Wendy's 1000 Masterpieces/by Sister Wendy Beckett. — 1st American ed.
p. cm.
ISBN 0-7894-4603-0 (alk. paper)
1. Painting, History I. Title II. Title: Sister Wendy's one thousand masterpieces.
ND160.B425 1999
759—dc21
99-20355
CIP

Colour reproduction by GRB Edice s.r.l.
Printed in Italy by Mondadori, Verona

 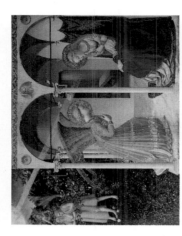 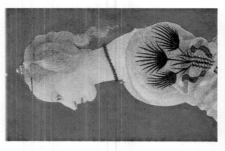 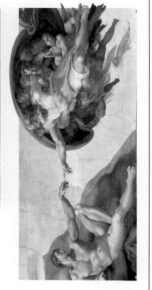

FOREWORD

SOME PEOPLE FIND THE VERY IDEA OF MASTERPIECES IRRITATING: an elitist attempt to impose high culture. The medieval apprentice would have found this baffling. Whatever his craft, he graduated into the happy position of being a master when he had served his time and produced his "masterpiece." At this homely level, an artist's masterpiece is a solid piece of work – well constructed and admirable – making no claims to world importance. Such a work can bring endless pleasure, and the least of the paintings in this book is just such a masterpiece. However, this is a masterpiece at its most modest. If every painting in this book is a masterpiece, then some are more masterly than others. Great art offers more than pleasure; it offers the pain of spiritual growth, drawing us into areas of ourselves that we may not wish to encounter. It will not leave us in our mental or moral laziness. It is not just that we are privileged to see the world through the insight of a genius – great though that experience is – but that the painter's insights awaken and challenge us, and we end up changed. We pass from the less demanding to the more, and then back again, constantly widening our love, knowledge, and understanding. Part of the fascination of this book is the divergence of quality: always good, sometimes great, sometimes overwhelming – absolute masterpieces like the Sistine Chapel, which are among the world's greatest achievements. I defy anyone to find a work here unworthy of its place, although you might well wonder why this particular work was chosen rather than that! Where is your favorite Giotto, or Picasso's *Guernica?* (The answer to the last is that it is not here because I think it is a wonderful propaganda poster rather than painting.) A thousand sounded so many until we got down to it and then began the anguish of choice. This is a book where the pictures alone matter; the purpose of the text is to keep you in the presence of the painting. Look long enough, and each one will work its magic on you.

Sister Wendy

CONTENTS

ALBERS, JOSEF 1888–1976 b. Germany

STUDY FOR HOMAGE TO THE SQUARE

THE EXTRAORDINARY SUBTLETY with which colors interact – how one shade can change another and relate to a third – so fascinated Josef Albers that he decided to restrict his paintings to geometrical patterns. By using the square, that most common of forms, he hoped to withdraw the viewer from any involvement in the interest of the actual object. But in blending and relating colors within the square, he hoped that the eye would be infinitely tantalized and delighted by a sense of what color truly was. (He claimed, for example, that he had eighty kinds of yellow alone.) Here, he is playing with a deep pink, with the square that encloses it in an infinitesimally lighter pink, and, outside that, a pale orange – all held within another square of a still-lighter orange. This is the kind of subtle modulation of color that a casual glance all too easily misses. Albers sacrificed so much of the interest and beauty that we expect from a work of art, solely in order to concentrate on this color play. In doing it, he makes us aware of the lovely silence that, with intelligent perception, can flow from one color to another.

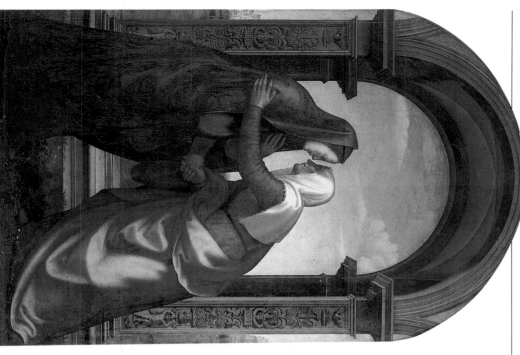

THE VISITATION, 1503,
oil on wood, 91 x 57½ in (232 x 146 cm),
Galleria degli Uffizi, Florence

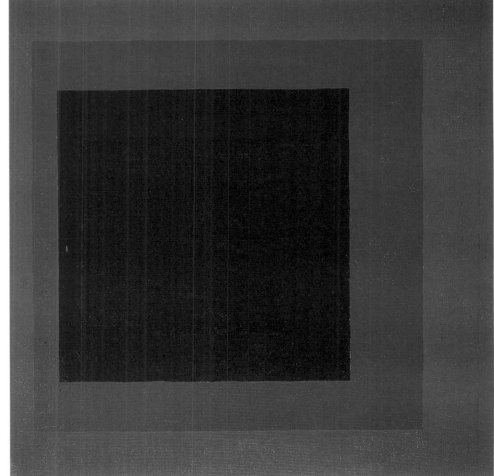

STUDY FOR HOMAGE TO THE SQUARE, 1972, oil on masonite 24 x 24 in (62 x 62 cm), San Francisco Museum of Modern Art

ALBERTINELLI, MARIOTTO 1474–1515 b. Italy

THE VISITATION

IN THE GOSPELS, we read how Mary was told that her elderly cousin Elizabeth had become pregnant with John the Baptist and that she set out to help Elizabeth. When the women met, the children in their womb – Jesus and John – seemed to communicate. Elizabeth said that she could feel her unborn child leaping for joy. The image of the two pregnant women meeting and communicating is a beautiful one, and Albertinelli depicts it in all its dignity. Both women are majestic figures, meeting before a great arch that symbolizes the entrance through the womb into history that their unborn sons will soon be making. Elizabeth bends humbly before the mother of her Lord while Mary has the extraordinary experience of meeting, for the first time, one who understands her singular destiny. The clasped hands, the inclining bodies, the meeting of the eyes – all express with understated power this communion of spirit. Albertinelli seems to understand the rarity of meeting another who can enter into one's own experience. It seems to be a meeting between two heroes. Mary's beautiful face is awestruck as she looks with a tender smile at the elderly woman who embraces her. There is a beautiful richness of color here: the flowing golden-orange and dark green of Elizabeth's clothes and the rough wool of her white scarf make a wonderful union with the subdued splendor of Mary's blue and red. The intensity, of both emotion and color, leaves no space for the landscape that is just visible at either edge. These two rejoicing women are a country all to themselves.

ALLORI, CRISTOFANO 1577–1621 b. Italy

JUDITH WITH THE HEAD OF HOLOFERNES

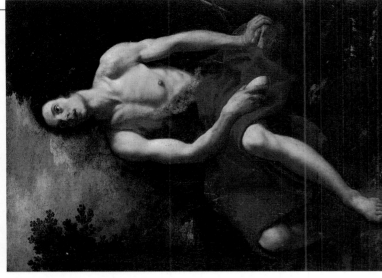

WHEN HOLOFERNES INVADED PALESTINE, it was the beautiful widow Judith who went into his camp, lured him with drink, and then, when he was insensible, beheaded him, carrying the trophy back in triumph to her people. This powerful woman fascinated many Renaissance artists. She subverted the feminine role, taking for herself the emotions of aggression and triumph – something, apparently, that men of the time feared in womankind. Allori's Judith possesses an exceptional loveliness: her face is both sensual and pure. She poses for us, aware of her status as heroine, one who controls the situation with effortless ease. But the very innocence and grace of her appearance make the dichotomy between what she is and what she has done seem more alarming.

ST JOHN THE BAPTIST IN THE DESERT

c.1620s, oil on canvas, 70 x 63 in (177 x 159 cm), Galleria degli Uffizi, Florence

Allori's St John the Baptist is a beautiful young male in the full flush of his strength, whose animal skins remind us of the lion-skin of Hercules. This is a benign desert, in which a small stream sparkles beside him, and it may well depict the moment when the idea of baptism struck him – he would dip his container in the waters and pour them over the heads of penitents as a sign of God's forgiveness. In this moment of epiphany – of revelation – John is rapt, oblivious to all but the vocation for which he has long prepared and now understands.

THE SEVERED HEAD is that of a mature tyrant – a savage head, outlined by the golden damask of her garment, and forming an intriguing contrast with the slender elegance of her own head, which rises almost directly above it. The face of the maid is an elderly contrast to both. Her look of awe and unease emphasizes for us the true magnitude of the act that this casual and beautiful young woman has brought herself to perform.

ONE NOTICES THAT the body under the robes is slender – this is a very young woman, however daring her deeds. She is dressed in robes of the utmost richness and splendor. Allori, great Mannerist that he was, has delighted in the richness of the textiles, but perhaps the image that remains with us longest is the plain white headgear that frames the ancient and dismayed face of Judith's follower.

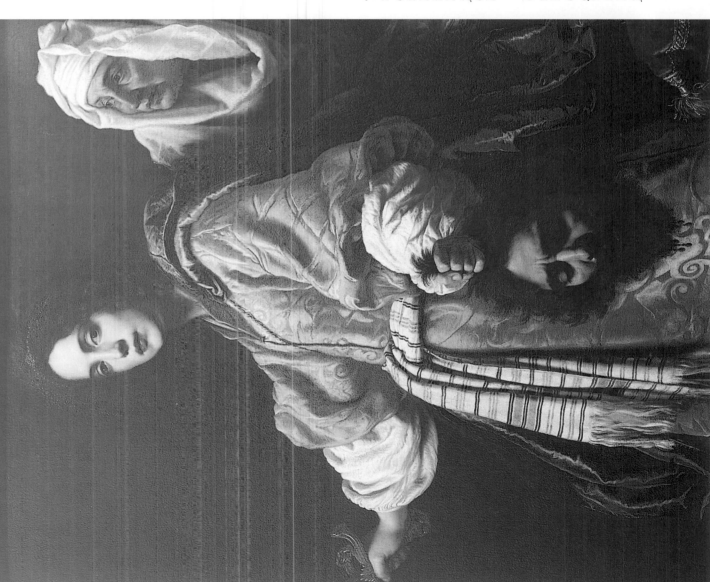

JUDITH WITH THE HEAD OF HOLOFERNES, 1619–20, oil on canvas, 54 x 46 in (139 x 116 cm), Galleria degli Uffizi, Florence

ALMA-TADEMA, SIR LAWRENCE

1856-1912 b. Netherlands,
active England

UNCONSCIOUS RIVALS

THE VICTORIAN UPPER-CLASS SCHOOLBOY basically studied nothing but Latin and Greek, and it was in that context and for that clientele that Alma-Tadema created his extraordinary evocations of that lost classical world. He took historical accuracy very seriously, but, as we can see from this painting, he infused it with a romantic passion. This lost world, with its marbles, gladiators, and imperial follies, haunted the imagination of Queen Victoria's British Empire, and whether Alma-Tadema was accurate or not, he was felt to be so, and felt it so himself. Here, he shows two Roman beauties in a setting of extreme opulence, and the suggestion is that this is one of those Roman pleasure villas that were built around Naples. The girls are each rapt in some erotic reverie, waiting, it would seem, and in this luxurious setting the implication is that they are waiting for a lover.

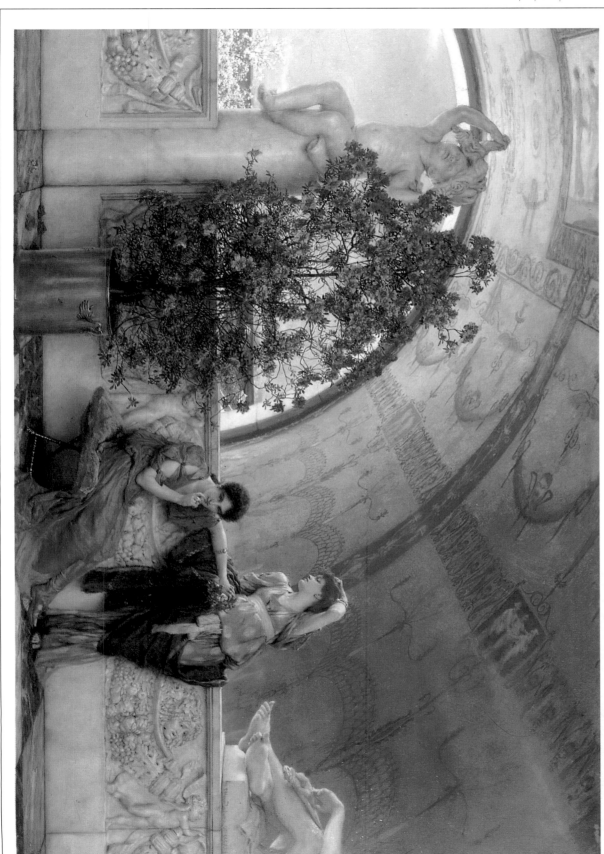

UNCONSCIOUS
RIVALS, 1893,
oil on panel, 18 x
25 in (45 x 63 cm),
Bristol Museum
and Art Gallery, UK

ON THE LEFT is a marble cupid; on the right are the feet of a statue of a gladiator. Gladiators were the toy-boys of Imperial Rome and, whether or not this is the subtlest here, there is certainly a feeling that more is going on beneath the surface than we are aware.

A FAVORITE CUSTOM

1909, oil on panel, 26 x 18 in
(66 x 45 cm), Tate Gallery, London

Here, in the cool ambience of the Roman bath, Alma-Tadema is able to delight those who cherish the classical way of life, while, with perfect propriety, introducing the theme of the nude. The communal bath fascinated his contemporaries and afforded the artist every occasion to show his technical skills. This is a calm, cool, alluring picture, with hints of implicit narrative that add to its attraction.

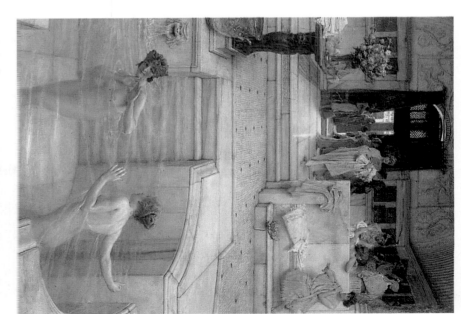

ALTDORFER, ALBRECHT c.1480–1538 b. Germany

ALEXANDER'S VICTORY

ALTDORFER WAS AN ARTIST OF DAUNTING AMBITION. *Alexander's Victory* does not merely record the outcome of the Battle of Issus, nor does it simply show the massed movement of combat; in this painting, Altdorfer attempts nothing less than to encompass the whole known world, which that battle was to affect. He starts in the sky, with an announcement of the importance of what we are to view; the ringed and tasselled rope that hangs from the heavenly plaque leads us directly down to the central event. A tiny Alexander, lance at the ready, charges towards Darius III, who can be seen further ahead, fleeing in his chariot. For the rest, huge surging multitudes struggle ignorantly and vainly – flags wave, lances advance, and men fall. Yet all seems to us bloodless and silent because, along with the artist, we are entirely removed, looking down on these horrors without concern. The encampments of the armies seem no more real or unreal than the castles and fortresses they surround.

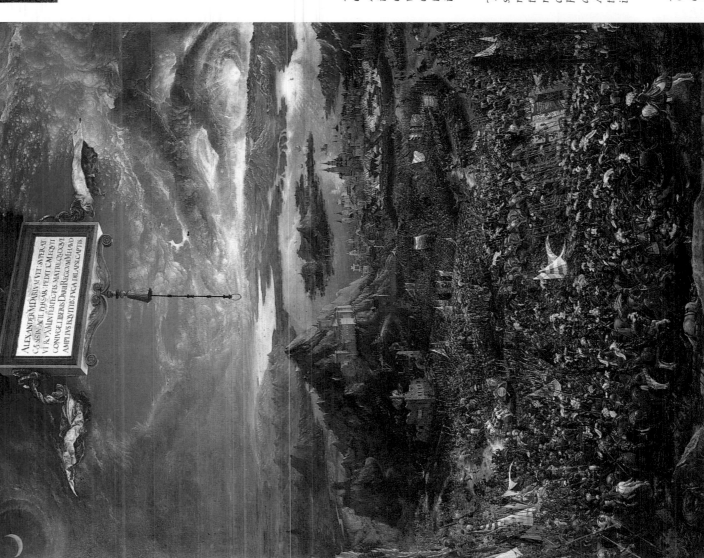

ST GEORGE

1510, oil on wood, 11 x 9 in (28 x 23 cm),
Alte Pinakothek, Munich

The Roman mind and the Teutonic mind were moved by different impulses: one towards the order of the high road; the other towards the dark mystery of the forest. Altdorfer is essentially painting the weird encompassing wilderness of the German forests, but he gives his picture a focus and a theme by entitling it *St George*. This *St George* is not in his usual scenario (saving the princess before an admiring crowd); instead, he is tackling the dragon alone and for his own sake. Essentially, like all of us, the knight is on his own, and Altdorfer sets him in the echoing silence of the forest to make this poignantly clear.

ALL THIS INFINITE expenditure of energy is set in the real landscape of the Mediterranean world, with the Red Sea in the middle. On the right is Egypt and on the left the Gulf of Persia. Far away, we see the long, narrow needle of the Tower of Babylon. All these great expanses of territory will be affected by what takes place in miniature in the center of this huge canvas.

THE VERY SUN in the sky is setting in horrified splendor behind the mountains, as if to emphasize that this is a world affected by nature but ruled by men and their individual choices. Only a few solitary soldiers on horseback at the very edge of the picture are recognizable as individuals, and yet Altdorfer involves us, should we choose to make the imaginative effort with him, in one of the great sagas of all time.

ALEXANDER'S VICTORY
(or BATTLE OF ISSUS), *1529,*
oil and tempera on wood, 62 x 48 in
(158 x 121 cm), Alte Pinakothek, Munich

ALTICHIERO DA ZEVIO c.1330–95 b. Italy

THE BEHEADING OF ST GEORGE

ALTICHIERO IS AN INTRIGUING 14TH-CENTURY ARTIST about whom we know very little except that he seems to have looked long and hard at the work of Giotto. He has clearly understood the fundamental revolution in the way of regarding the human body that was Giotto's supreme contribution to painting. Altichiero shows us solid figures with three-dimensional reality. He understood even more Giotto's interest in human drama – the relationships between people – as is evident in this painting, where we see St George with head bowed to receive the executioner's stroke. All those around are intimately involved in the tragedy. On the left, a father leads away his child, who, like all youngsters, is fascinated by the prospect of the bloodshed but will be horrified by its actuality.

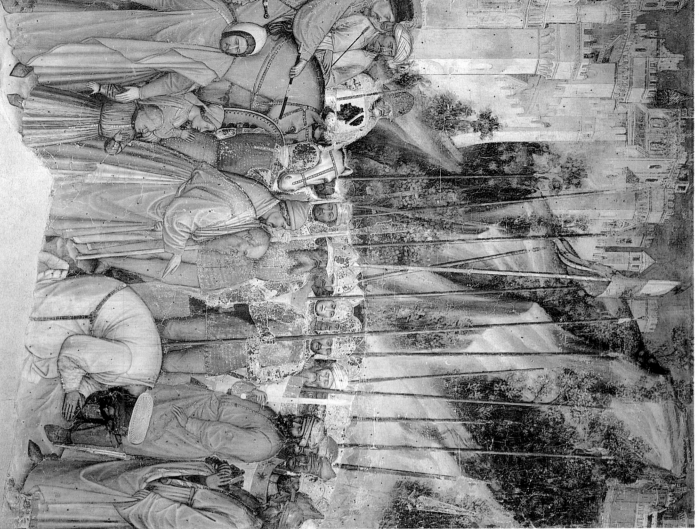

THE BEHEADING
OF ST GEORGE (DETAIL)
c.1382, fresco, dimensions not known,
Oratorio di San Giorgio, Padua, Italy

THE PAGAN PRIEST still harangues, with anxious futility, the resolute back of the kneeling saint, while the various grandees and soldiers look on with sadness. Legend has it that St George himself was a soldier, and these may well be his companions in arms. Even the executioner is seen by Altichiero as a living personality, carefully measuring with his eye where he will place the sword.

AS WELL AS STUDYING GIOTTO, Altichiero had also looked at Simone Martini, hence the glory of Sienese color here – the pinks, the blues, and the pale yellows. The circle of people involved in this terrible act is put into perspective by the upper half of the picture: on one side, the great tall towers of authority; on the other, the mighty cliffs of nature. Land and sky will endure long after the sorrows of this martyrdom have passed away.

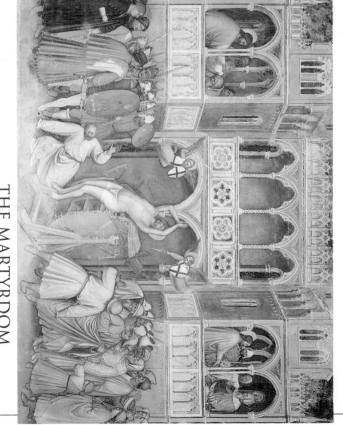

THE MARTYRDOM
OF ST GEORGE (DETAIL)
c.1382, fresco, dimensions not known,
Oratorio di San Giorgio, Padua, Italy

This is another image from the long and painful progress of St George from hero on horseback to beheaded martyr. This shows the pagans' attempt to execute him on the torture wheel. The martyr, in the center of the picture, is strapped to the wheel, which is visibly exploding to the astonishment and horror of those who have assembled to see the death. St George is poised to spring upwards, like a diver in reverse, to that world above – the world to which he aspires. On one side, Christ blesses and pardons; on the other, He encounters His judges. Both images of Christ reflect events in the life of St George.